Pages From My Notebook

Declarations about God, Love, Healing, and Manifesting My Best Life

MELISSA A. MITCHELL

Copyright © 2022 by Melissa A. Mitchell

All rights reserved. No part of this publication may be reproduced, distributed, or transmitted in any form or by any means, including photocopying, recording, or other electronic or mechanical methods, without the prior written permission of the publisher, except in the case of brief quotations embodied in critical reviews and certain other noncommercial uses permitted by copyright law. If you would like permission to use material from the book (other than for review purposes), please contact the publisher. Thank you for your support of the author's rights.

Mynd Matters Publishing
715 Peachtree Street NE
Suites 100 & 200
Atlanta GA 30308

978-1-957092-06-5 (pbk) | 978-1-957092-07-2 (hdcvr)

To those who decided to write the vision and make it plain for their lives. No longer will we allow life's up and downs to dictate who we are and who we are to become. We control the pen to our story, the brush to our canvas, and the light to our path. May we never forget that, even on our worst days, there is still a chance for life to get better. Change begins when we truly believe we have all the power we need within. We all deserve the life we have the courage to believe God for...starting with dreaming bigger today.

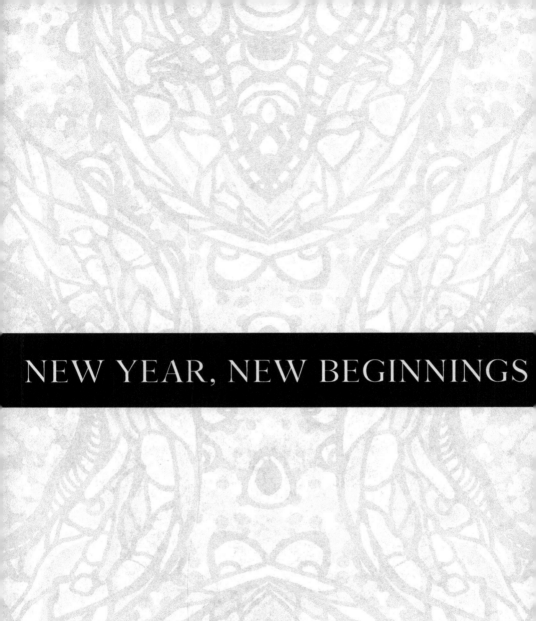

NEW YEAR, NEW BEGINNINGS

THE CALENDAR YEAR MAY CHANGE, BUT IT MEANS NOTHING IF YOU CHOOSE TO TAKE THE SAME THINGS THAT HAVE WEIGHED YOU DOWN INTO THE NEW YEAR. YOU CAN START YOUR NEW YEAR AT ANY POINT IN YOUR LIFE. CHOOSE TO LOOSEN THE SHACKLES THAT HAVE KEPT YOU STAGNANT. YOU HOLD THE KEY TO YOUR OWN LIBERATION. GO AFTER WHAT YOU LOVE, DESIRE, AND REQUIRE.

Instead of pressuring yourself to create a "must list" for the new year, isolate yourself for a few days to truly hear from God.

Many of the same areas remain undone year to year because God has a different plan. Do not be discouraged.

Know that He has it under control.

A new year means nothing if you're committed to being the same person, doing the same things, and going to the same places. Before the new year arrives, start thinking of ways to become better. A new year is merely an opportunity to switch it up for the better. Remember, you hold the power to alter your course.

It's been such an amazing year.
I will never get tired of telling God
"THANK YOU."

*I did everything I said
I would this year.*
I did it sick.
I did it scared.
I did it nervous.
I did it blind.
I did it alone.
But —
I had God.
I had faith.
I had family.
I had ancestors.
I had guts.
I had creativity.
I had visions.
I was always me...
**and that's the difference
maker every single time.**

No matter where you've gone, what you've said, or what has happened in your life, God's plan for you never changes. The plot of your story remains the same, you are merely adding depth to your chapters.

66

If you made it to today, you have another chance to get it right. **Stop focusing on your failures** and start focusing on your future. You can't change the past, but you can certainly have a hand in the future.

Today is the perfect day to start fresh in the right direction. It's never too late.

THERE ARE NEW OPPORTUNITIES
THAT HAVE ENHANCED YOUR
LIFE WHILE OTHERS HAVE COME
TO CHALLENGE YOU. ALL IN ALL,
IT GOES TO SHOW YOU WHAT
AN AWESOME GOD WE SERVE.
DESPITE THE UPS AND DOWNS,
HE'S ABLE TO USE IT ALL FOR
YOUR GOOD. IF YOU HAVEN'T
SEEN ALL THE GOOD YET,
IT IS COMING.

Life is all about asking the right questions.

**EVEN
IN THE
SHADOWS,
THERE
IS THE
PRESENCE
OF LIGHT.**

Be open to seeing what God is trying to show you.

How can you predict the future?

You can't.
Just trust it.

God doesn't need your permission to use you as a (positive) example.

STOP BEING CLOSED OFF TO MIRACLES. GOD WANTS TO GIVE SO MUCH TO YOU.

It's all about timing.

It's all about sacrifice.

It's all about discipline.

It's all about fortitude.

It's all about focus.

It's all about faith.

It's all about God.

That's my definition of success.

"

SOMETIMES PLANS CHANGE, BUT ALL THE TIME, GOD IS GOOD.

You would be surprised at whose life is on pause because you're not following your purpose. There is someone right now that is relying upon your obedience to take the leap that God wants from them.

Everyone needs to find their own way, and carve out their own life experiences.

66

Don't ever think you're too far from your purpose to get it right. It's (all) still part of your story. Trust God to know it can and will get better.

66

THE MOMENT YOU FEEL YOURSELF DRIFTING FROM WHAT YOU KNOW GOD WANTS OF YOU, YOU NEED TO PAUSE AND GET BACK ON TRACK. NOTHING IS WORTH COMPROMISING YOUR PURPOSE OR YOUR GOALS.

God will stop everything you've been trying to do on your own and then release it all at once, so you KNOW *it's Him.*

THERE WILL BE NO MISTAKING GOD'S WORK AND HAND ON YOUR LIFE WHEN THE LEVEES OF OVERFLOW BREAK. GOD'S SIGNATURE IS UNIQUE AND READILY IDENTIFIABLE.

Do not be discouraged on your journey. You really have to trust the process. And that's not rhetoric. Everything God allows has a distinct purpose.

66
When you look
back, It will be
evident that He
was with you
all along.

Never question why you've been chosen to endure certain trials and not others. When you experience great things again, many will wonder why you've been so "lucky." Your trials are down payments on your breakthrough. Nothing you experience is by mistake. God's going to use it all to promote you right here on Earth.

In a single moment, *God can change your life for the better!* **Trust His timing for what He's up to.**

MANIFESTING

"

Imagine what you could manifest if you really tried.

We are in a rare season of accelerated manifestation. God is about to SHOW OUT in some of our lives. When it all falls into place, will you be ready?

"

THE SECRET
WEAPON TO
MANIFESTING IS
WRITING. YOU HAVE
TO MAKE THE
VISION *PLAIN*. AND
YOU MUST READ
AND WRITE IT
EVERY DAY.

Every blessing attached to your name is **ATTACHED** to your destiny. If you truly commit your ways to the Lord, the sky isn't even the limit. That's the secret. The key to waiting is to act as if it's already happened.

"

Stop right now and list everything you think may be holding you back. Reevaluate the list, think of the origin of the obstacles, and pray for the strength to overcome them. Then, take the list, rip it into small pieces, and declare yourself the victor over it all. Decide to leave it all behind and get ready for your new chapter. The time is NOW!

Our dreams are merely one person, connection, call, and/or meeting, away. The only thing we need to do is act like our dreams are already a reality. If you want to acquire a certain level of wealth, start riding around in those neighborhoods, looking at luxury cars, and learning all about wealth. If you want to become a well-known singer/artist, start attending musical events and hanging out at art galleries. You have to get your mind conditioned for the life you dream of.

"

DON'T LOSE SIGHT OF WHAT YOU DESIRE BECAUSE YOU DON'T SEE IT HAPPENING WITHIN YOUR TIMELINE. TRUST GOD. EVENTUALLY, IT WILL ALL MAKE SENSE AND YOU WILL BE GLAD YOU ALLOWED GOD TO DO HIS THING.

What you need/want in life is often hidden in what you have. Ask God to show you what He saw you doing with it. He will, indeed, direct your path.

"

STOP LETTING THE POSSIBILITY OF DEATH BE YOUR ONLY REMINDER TO LIVE. LIFE IS PRECIOUS, AND WE ARE RACING AGAINST A SILENT CLOCK. OUR MOMENTS ARE TOO VALUABLE TO WASTE SO CHOOSE HOW YOU SPEND THEM WISELY.

No matter how many great things you're able to manifest, never lose sight of THE SOURCE.
Many times, we make gods out of things and people, and we forget to stay hungry for God, the one who provided it all.
So, no matter how much I'm able to manifest and accumulate, I will always give God ALL THE GLORY, publicly and privately.
GRATEFULNESS IS A LIFESTYLE.

" "

Stop behaving as if your tough days will last always. These moments can and will change upon God's command. Allow your trials to strengthen you on your journey. God uses everything to make you a better version of yourself.

" "

You deserve everything your heart desires.

"

The next level is going to require so much of you, that you have to cherish moments when your plate is NOT full. Because when the calls come, it's GO TIME!
The danger in responding to disappointment repeatedly the same way is that it becomes an ingrained behavior. We begin to filter our other experiences with the expectation of the same outcome from before.

THE BIGGEST
SECRET
TO BEING A
MASTER
MANIFESTOR IS
PRESSING YOUR
WAY WHEN
YOU ARE 111 %
OVERWHELMED.

"

YOU LITERALLY CANNOT LOOK AT YOUR CURRENT SITUATION AND BELIEVE THIS IS IT. YOU HAVE TO ALWAYS BELIEVE THERE IS MORE IN STORE. ALWAYS.

Visionaries focus on their goals and are willing to do something they hate to pave the way to do what they love. Don't despise your meantime. It "means" something. The next level will be upon you sooner than later. **Keep pressing.**

"

WHEN YOU PUT YOUR
HEART AND SOUL
INTO SOMETHING, THE
UNIVERSE WORKS BEHIND
THE SCENES TO MAKE
THINGS LINE UP FOR YOU.

Don't let someone who has found their dream (job. mate. opportunity. etc.) convince you to settle for the first thing that makes its way to you. Whether it is a job that is just "ok." or a potential mate that knows their ABCs (and has most of their teeth). or an opportunity that only offers a fraction of what your heart yearns for. don't settle. If there is a tugging in your spirit to wait. then wait. Don't let someone push you toward something you will regret. You deserve what you desire.

Trust God and His timing.
Your dream exists.

"

**YOUR GOAL SHOULD
NOT BE TO AIM
AT PERFECTION.
YOU SHOULD AIM
FOR CONSISTENT
OBEDIENCE.**

"

*In all thy
ways, be
intentional.*

When small things
around you become
major distractions,
they are meant to
throw you off course.
This is an indication
that something major
is on the horizon.
Remember to stay
focused on your
intended goal(s).

I'm not
searching
for
abundance.
I Am
Abundance.

"

I'm wholly committed to my **NOW** and my **NEXT**. My prayer is to never rush to one season without fully f inishing my assignment in the current one. That's the best way to **avoid repeating lessons unnecessarily.**

WE DESERVE EVERYTHING WE HAVE THE COURAGE TO BELIEVE GOD FOR.

YOU EVER WONDER WHY GOD STILL
HAS YOU WHERE YOU ARE? IT'S NOT TO
KEEP YOU DOWN. INSTEAD, HE MIGHT BE
TRYING TO USE YOU TO BRING SOMEONE
ELSE UP. DON'T DESPISE SMALL
BEGINNINGS OR SITUATIONS, THEY ARE
MERELY LAUNCHING PADS.

When you get a divine assignment, not everyone is going to understand/accept your dream. That is why it was given to you. Now run with it!

"

I've never been one to follow trends or the crowd. I know what God showed me and told me. I won't rest until I make it happen. And so the work continues. No matter what it looks like, we have to keep going. Eventually, everything will work together for your good. Your story/ journey is not just for you, but to inspire others to run after what God has placed in them. Be willing to see it through. Someone's destiny is contingent upon you running after yours.
Dream on dreamer.
I want it all!

(P.S. Be ready to do some work though)

You have to earnestly believe that everything you want, wants you.

"

EVERYTHING IS RIGGED IN YOUR FAVOR.

Don't let unanswered prayers exhaust you to the point of no longer believing.

"

The grind, the
sacrifice, the
losses, the pain,
the No's, the
isolation...
they all have
an individual
purpose, and it
will ALL pay off.

GOD AND FAITH

When you refuse
to move forward,
you're essentially
telling God you don't
think He's capable of
providing more
and better.

NO MATTER HOW LONG IT TAKES, GOD WILL ALWAYS KEEP HIS PROMISES.

66

God has a vested
interest in our
breakthrough(s).

He wants us all to win.

"

Every day I wait makes me great! If I can hold out to see what God has in store, there's nothing I can't have or do. Though the vision may tarry…wait!

GOD CAN CHANGE
ANYONE AND
ANYTHING FOR
THE BETTER,
AT ANY TIME.
**I REFUSE
TO BELIEVE
OTHERWISE.**

66

God has something for
you. There's nothing
you or anyone else can do
about it. While your
journey may be tumultuous
at times, He has your
appointed promises
waiting on you.
No one can take
your slot!

WHEN YOU PRAY, EXPECT CHANGE. STOP HAVING LOW EXPECTATIONS BASED ON SOMETHING FROM THE PAST. BE CAREFUL WHO YOU SHARE YOUR EXPECTATIONS WITH. NOT EVERYONE POSSESSES THE SAME FAITH NOR ARE THEY WILLING TO STAND IN THE GAP FOR YOU LIKE YOU THINK THEY WILL. YOUR FAITH WALK IS UNIQUE TO YOU. WHEN IT COMES TO PASS, YOU WILL KNOW IT'S GOD AND GOD ALONE. EVERYONE DOESN'T HAVE TO UNDERSTAND WHAT GOD DID FOR YOU. BEGIN TO PRAISE IN ADVANCE BECAUSE HIS PROMISES WILL COME TO PASS!

"

It's not how you act when you're on top of the world that shows who you truly are. It's how you act when your back is against the wall. Don't ever give up on God or what He's promised. He definitely hasn't given up on you.

NOT ONLY WILL GOD ELEVATE YOU, HE WILL DO IT PUBLICLY, SO EVERYONE CAN SEE IT. EVEN IN FRONT OF THOSE WHO DIDN'T THINK IT WAS YOUR TURN. THAT'S HOW GOD WORKS. HE WILL SHIFT SOMETHING JUST FOR YOU, AT JUST THE RIGHT TIME.

MAY THIS SEASON BE FULL OF EXPECTED AND UNEXPECTED WINS THAT MAKE ALL THOSE TEARS WORTH IT.

66

Listen: You have to take that step, leap, jump of faith. You have to give God something to work with. If you don't move, how can you expect Him to? When you feel like you're against the wall, lift your hands for help. God will always make a way of escape. Trust Him.

THE ESSENTIAL
PART OF GETTING
READY FOR WHAT'S
NEXT IS TRUSTING
GOD TO LET GO OF
WHAT'S RIGHT NOW.
EVERYTHING YOU
THOUGHT WAS GOOD
CAN BE TRUMPED BY
GOD'S **GREAT**.
TRUST THAT HE WILL
REPLACE IT ALL.

"

Please don't think it's over for you. God may have just pressed the reset button in a certain area of your life. God will show Himself strong again for you!

66

Just because you don't see God moving in one area in your life, doesn't mean He won't.

66

God loves you too much to let you carry anything that will kill your vision or spirit. Surrender to His will if He's instructing you to let things (or someone) go!

*Radical faith
requires radical
action*
BEFORE
*you see
anything
happen.*

"

Sometimes, God has to let you experience rejection from something you truly want in order to preserve and prepare you for a promotion to what you need and deserve. God has a tailor-made promotion for you.

Nothing you want can supersede what **God** wants and has for you.

When you are used as God's
conduit, don't think you're
immune to the enemy's attacks.
You can actually become
target because you're helping
people get closer to God.

But atthe same time, God
has your back even more.

So keep blessing folk and
watch God mount you up
on eagle's wings above all the
enemy's ploys.

GOD KNOWS WHAT TO SEND YOU AND WHEN TO SEND IT. HE ALSO KNOWS WHAT TO WITHHOLD.

Just when you've decided to let go, God will send you a message to NOT give up. Don't ignore the signs and wonders He sends to save you!

WHEN YOU
LEAST EXPECT
IT, GOD WILL
MAKE UP FOR
ALL THE TIME
YOU THINK
YOU LOST.
THE KEY IS TO
EXPECT IT!

"

God has your name on a list, being reviewed by someone with great resources and influence. They are ready to change your life and business for the better. Your call/email is coming. Get ready like you've already been contacted!

LOVE AND SELF-LOVE

"

The greatest gift we can give is love. Remember to love without keeping score. Love without limits. Love without remembering hurt. Love like your life depends on it. We all need love to survive, regard less of our past experiences. Tell someone you love them. That's a precious gift!

The calls will come, the job will come, the promotion will come, the friends will come, the abundance will come, the love will come, the money will come, the opportunities will come — no good thing shall be withheld from you. (write Psalm 84:11 on the tablet of your heart)

"

Only you know where you've been.
Only you know what you've endured.
Only you know what God promised you.
Only you will possess what God has tailor made for you.
Only you...

Be careful who
you don't count.
The person you
least expect may
have the key to your
miracle. You never
know who God
will use.

"

**THE BEST THING
YOU CAN DO
IS LET PEOPLE
SERVE THEIR
TIME IN YOUR
LIFE AND THEN
FREE YOURSELF
OF THEM WHEN
THEY ARE GONE.
CAN'T LIVE A LIFE
OF REGRET WHEN
THERE IS NO
REWIND BUTTON.**

Don't let people dictate how you spend your time, energy, and efforts.

You really do have to surrender timelines and focus on getting closer to God — and learning who you are.

Be careful about who you let into your space. Not everyone deserves access to your vulnerabilities.

As you go through life, understand that you will endure tough trials, but it's up to you to choose how you respond.

99

DON'T ALLOW WHAT YOU'VE
BEEN THROUGH TO CHANGE
WHO YOU ARE. LIFE HAS A
WAY OF GIVING YOU THE BEST
THROUGH THE MOST UNLIKELY
SOURCES.

99

DON'T APOLOGIZE FOR YOUR
EVOLUTION. WITH TIME AND
EXPERIENCE, YOU SHOULD
BEGIN TO EVOLVE INTO
A GREATER VERSION OF
YOURSELF. SOME CAN HANDLE
A BETTER YOU WHILE OTHERS
WEREN'T MEANT TO BE AROUND
FOR IT.

Love and
friendship are
incredible forces.
Both are essential
to the soul.
So grateful
to know the true
meaning of each.

"

LOVE IS BIGGER THAN
AN EMOTION, IT'S AN
EXPERIENCE. LOVE
IS AN EVOLUTION
OF THOUGHT AND
PROCESSES. IT'S A
COMMITMENT TO
PUSHING ONE TO THEIR
POTENTIAL WHILE
MAXIMIZING YOUR
OWN. IT IS IMPERATIVE
TO PARTNER WITH A
BEING THAT LOVES YOU
EFFORTLESSLY AND
ONE THAT CHALLENGES
YOU FROM A PLACE OF
COMPLACENCY. LOVE
SHOULD NEVER LEAVE
YOU UNAFFECTED.

Be careful what you share. Everybody ain't praying with you, and everybody ain't happy for you. If God gave you a dream, protect it and work your plan. In due time, the world will see how magnificent you are. Be careful what you reveal.

Love is born when your soul is awakened, your senses are heightened, and your eyes look past the surface to find something real. At some point, you realize it's bigger than just attraction. It's about purpose and partnership. If he/she can help you resurrect dormant gifts within and push you to cultivate your talents, do not overlook them. If this person understands how to minister to your spirit man, he/she is certainly one to keep in your life. If he/she can speak to the God in you, you may have found what your heart has been searching for. Don't be fooled into thinking love is grown in a magical moment or will appear suddenly. Love grows where it is allowed. Open your heart, your mind, and your eyes. You could have been staring at love for a long time and didn't even know it. Act now before it dissipates.

You're allowed to be imperfect.
Carry on, beloved.

Remember: Everything doesn't
deserve a response.

I don't want it if it ain't for me.

May we all manifest a love that
asks us to be nothing but ourselves.

I almost robbed myself of my
greatest experiences because
of fear.

"

YOU HAVE TO DO WHAT YOU HAVE TO DO JUST TO BE HAPPY. ABANDON YOUR OWN RESTRICTIONS AND FREE YOURSELF FROM THE OPINIONS OF OTHERS. IT'S ONLY A MATTER OF TIME BEFORE WE TRANSFER TO ANOTHER REALM.

"

BECAUSE IT MAKES SENSE TO ME, IT DOESN'T HAVE TO MAKE SENSE TO YOU.

"

SOME PEOPLE AREN'T QUALIFIED TO BE IN YOUR LIFE, YET YOU KEEP TRYING TO GIVE THEM PROMINENT POSITIONS ANYWAY. GOD HAS PULLED THEIR FILES AND ISSUED THEM THE PINK SLIPS SINCE YOU COULDN'T DO IT. IT'S REALLY FOR THE BEST.

Leave whatever you need to leave behind, and refuse to look back. You don't need a face-to-face meeting, one last call, or messages sent by dove-none of that. Begin your healing and prepare for greater. It's easier said than done BUT it has to be done. Imagine what you're holding up by dwelling on something you're waiting to "close." Instead, count your losses, pray for the (daily) strength to move forward, and find the courage to pray for what you deserve.

It's ok to not have a good day. And it's ok to not share all the details. Some stuff is just for you and God to work out. Sit in the emotions and let them flow. Eventually, you will feel better. But if you ignore those feelings, you will be a walking volcano. Allow yourself to feel.

GRATEFULNESS AND GRATITUDE

66

Be grateful for what you have before it's gone.

When you know what God said, don't second-guess it. His plans haven't changed for you. It's never too late to get back on course.

Stop praying for something you aren't willing to maintain. The next level requires more of you. Are you really ready for it?

You're the light that someone is searching for.

66

Don't be disappointed by people. Their time simply may be up in your life. Trust and believe He's got something tailored for your next season. No more tears. **Let go!**

God never changes, but His methods of operation do. He will give you what (who) you need when you need it (them). Learn to let go of what He's taking from you, so you can receive your new portion.

Sometimes, it's best for nothing to work out for a long period of time, so when it finally happens, you know, without a doubt, it's ALLLLLLL GOD. No one will be able to get the credit for what He's done and will do.

Story of my life...
"IT'S ALL GOD."

Be brave enough to do what you love and let God iron out the rest of the details. Many times, we lose our passion for something because we get tangled in the "what ifs." At this point in life, I say, "Go for it!" You will miss 100 % of the opportunities you never take. You never know what will come of an idea until you try.

When God begins to pour out blessings, there is not one container that can hold it. That's why God surrounds you with (the right) people to pour your overflow into.

There are some people in your life that weren't here before, and there are some that are gone that have been with you along the way.

God promises to finish the great work He's started in you. Although I don't have everything on my "list," I am grateful to still be kept in the midst of it all.

Sometimes, you just have to thank God for **NOT** giving you what (and who) you wanted when you wanted it (or them).

Because when you **FINALLY** get what is truly meant for you, it means so much more. The praise is so much sweeter. The worship is so much deeper. And the tears have so much more meaning.

GOD WILL PLACE A DREAM SO BIG IN YOUR HEART THAT YOU WILL HAVE TO ENTRUST PEOPLE AROUND YOU TO EXECUTE IT.

FOLLOWING YOUR DREAMS ISN'T JUST FOR YOUR OWN ELEVATION. GOD WANTS YOU TO PULL OTHERS UP, TOO. AND THEN THEY WILL DO THE SAME FOR SOMEONE ELSE. THAT'S HOW THE CYCLE OF GREATNESS KEEPS GOING. THAT'S HOW WE ALL WIN.

SOMETIMES YOU HAVE TO THANK GOD FOR THE THINGS (AND PEOPLE) THAT DIDN'T HAPPEN. AFTER A WHILE, IT WILL ALL MAKE SENSE. KEEP GOING.

When you're where you're supposed to be, you get what you're supposed to get. Divine positioning is key for making it to the next level.

If you have a gift, it doesn't matter where you are placed, you will shine. Purpose can exist anywhere. You can't run from what God has placed on your life! Decide today not to waste another moment by being out of His will.

(while waiting on my "why" and my "what," I write notes to myself (and future self)). It's amazing to see where God has brought me. It reminds me that this success was not overnight, and it also reminds me that I never lost sight of what God showed me.

Reality is not an accurate barometer for what God can do. When it's your season and His timing, anything is possible. Just hold on and see what God is about to do.

PAGES FROM MY NOTEBOOK

" God is more than enough. The rest is just a bonus. -Note to self

So, how did you survive last year?

I built a fortress over my mind, my gifts, and my soul.

I remained diligent in my pursuit of my goals, and I recognized the enemy's ploys as they unfolded.

I was never afraid to walk alone—it's ok to lose folks along the way.

I understood that there are certain visions given to certain people.

I learned that God will take from you what you aren't obedient or brave enough to release.

I don't have to go where I know I'm not celebrated, appreciated, loved, or uplifted.

I stopped having conversations with people who only knew what I knew.

I prayed for a succinct circle of prayer warriors, dreamers, and visionaries.

I prayed for wisdom and innovations over money.

I learned that the more selflessly you give, the more God will supply—abundantly.

I committed to rejecting thoughts of self-doubt, self-pity, and self-hate.

I've embraced that I'm different and isolation and pain were used as conduits to pull the real queen of out me.

Most of all, I've realized the greatest connection to God is felt when you know thyself. Cheers to not throwing in the towel and being a thriving survivor!

"

Art provides an eternal light that cannot be easily diminished, but can be transferred by merely experiencing it.

"

I USED MY TEARS AS A DOWN PAYMENT ON A BETTER LIFE.

"

MY GIFT IS BEYOND THE BRUSH. I AM DESTINED TO IMPACT SOULS AND TO MAKE THEM SEE THE GOD IN EVERYTHING.

Special Acknowledgments

Through the years, I have experienced a series of metamorphoses that have ultimately shaped who I am. From losing my father, to creating timeless art, walking major runways, manifesting two free cars, landing global deals, falling in and out of love, finally leaving my corporate job, traveling the world, and a host of other life-changing things, everything I've endured has made me the ultimate alchemist. I've used everything that has happened in my life to become the best version of myself. Along the way, I have picked up some pretty amazing people.

To my mom — You are my rock and my inspiration. It is my life's greatest joy to give you the world.

To my sister, Mo — You are my quintessential go-to for everything, the ying to my yang.

To my sister, Mel — You make me laugh, even when I am crying.

To my daddy in heaven — I promised you I would take care of the Mitchell name and the family, and I'm doing just that. Until they close the curtains, Mom, Mo, and Mel are forever good. And even after that, my art will take care of the rest.

To my BEST T — You've been my rock since we were making up raps in Mr. Lee's class. Love you for LIFE.

To J — Thank you for being my trusted manifesting, Taurus sis and my world traveling partner.

To Ash — Thank you for being my balance.

To A & M — I couldn't make life's biggest decisions without you two in my corner.

To S — Thank you for being my cussing and crying partner. Love you, my weasel.

To K & R — Thank you for being my day ones and never budging.

To Tai — I can never repay you for your unwavering belief in me. Thank you, sis.

To J-Mills — You've been telling me to write a book since my first post on FB, so here's a third one. Lol.

To E — Thank you for adding to the soundtrack of my life and showing me Atlantis.

To Ry — Thank you for always being available to create and going above the call of duty.

To Renita and the entire Mynd Matters Publishing team — Thank you for being a text away, bringing my vision to life seamlessly, and for never thinking my ideas are too big.

To my (future) husband and kid(s) — Thank you for giving me time to build this empire. See you soon.

To a host of others who support me daily — I thank you. I would be nothing without the continuous support. Rattlers, sorors, friends, mentors, supporters, clients, fans, line sisters, IG besties, and the list goes on. You know who you are, and I am forever grateful for each of you. If you think you have been missed on this list, insert your name here_____. Okay, we are even now. 😊

This book is dedicated to anyone who has felt lost and wanted to start over. The moment you understand the power of your words, you become a greater version of yourself. Pick up your pen and write yourself a new life. It may not happen overnight, but, at least, you can start tonight (or today). I did it, and so can you. Study Habakkuk 2:2 and Ephesians 3:20.

Every day is a chance to get this thing called life right. Believe you deserve better and then go after it. God can take what's extraordinary and make it routine in your life. Don't underestimate God's power to totally transform your life (for the better) in an instant!

There's so much waiting for you on the other side of this.

Today can be the day, if you believe.

Go for it all!

~MM

CPSIA information can be obtained
at www.ICGtesting.com
Printed in the USA
LVHW081616230322
714086LV00014B/2487

9 781957 092065